radiance

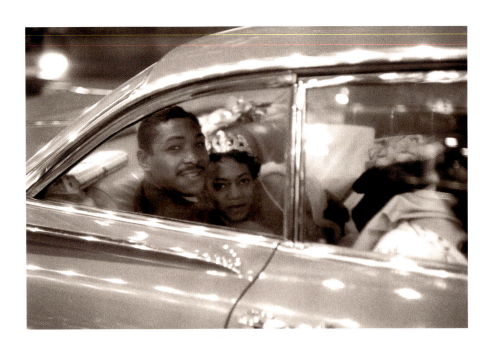

radiance

edited by Kelly Duane

CHRONICLE BOOKS

SAN FRANCISCO

Pages 65–66 constitute a continuation of the copyright page.

Library of Congress Cataloging-in-Publication Data:
 Radiance.
 p. cm.
 ISBN 0-8118-2516-7
 1. Brides—Pictorial works.
 GT2796.5.R33 2000
 391'.2—dc21 99-12754
 CIP

Printed in Hong Kong

Designed by Pamela Geismar using Bell Gothic,
Garamond Three, and Caravan Borders fonts.

Distributed in Canada by Raincoast Books
8680 Cambie Street
Vancouver, British Columbia V6P 6M9

10 9 8 7 6 5 4 3 2 1

Chronicle Books
85 Second Street
San Francisco, California 94105

www.chroniclebooks.com

introduction

When I first discovered my parents' wedding album as a little girl, I was mesmerized by the woman in the white dress—her simple veil of Italian lace, her classic white gloves, her luminous face. My mother always appeared beautiful to me, but never more so than in her wedding pictures. Her radiant smile stole the show in every photograph taken at her small San Francisco wedding on Nob Hill. I am now convinced, after working on this collection, that radiance is that ineffable quality that all brides share.

In choosing photographs for this book, I looked through hundreds of wedding photographs, from turn-of-the-century pomp to hippie weddings of the seventies to today's poised and glamorous affairs. All of the photographs had one thing in common: just like my mother, the bride, whether the center of a portrait, or caught amidst the action on the dance floor, was the true focus. In each bride's face I saw her presence in the moment, and her awareness of the momentousness of that single day. In one photograph, a woman peers contemplatively out a window with an expression both nervous and serene. In another, a just-wed bride strides blissfully from the church amid a throng of Scottish bagpipe players. And in another, a young woman, enraptured, leans toward her fiancé in their local city hall. I was drawn to these brides by the unfettered joy that shone in their faces. I was drawn to them because of their radiance—radiance that reminds me that love is extraordinary.

—*Kelly Duane*

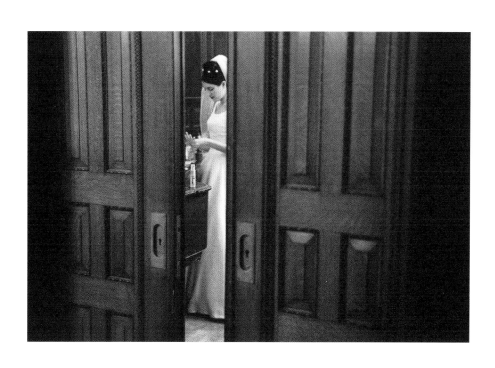

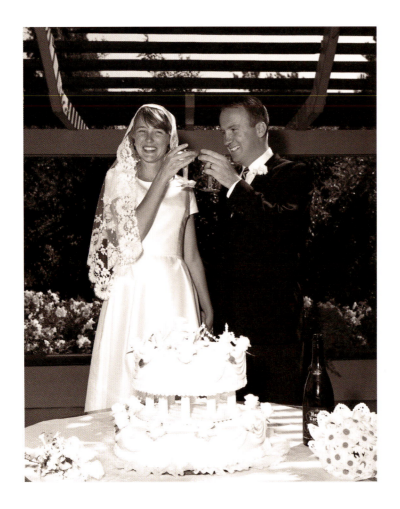

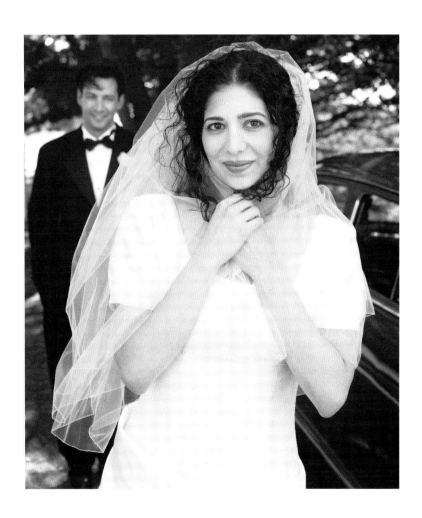

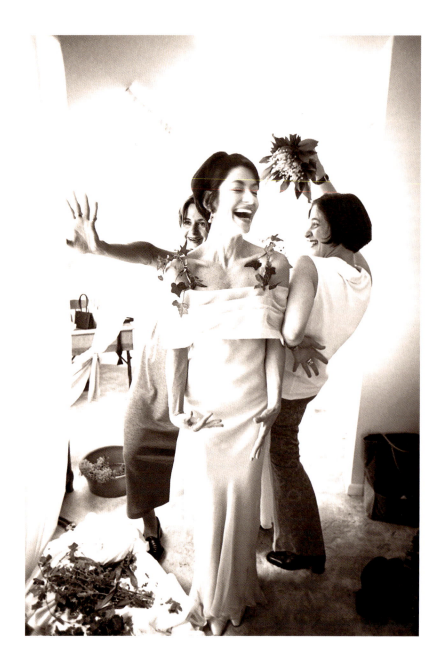

4

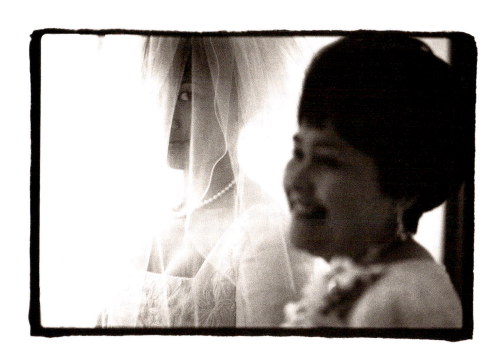

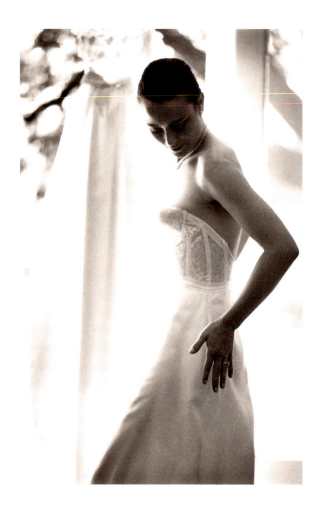

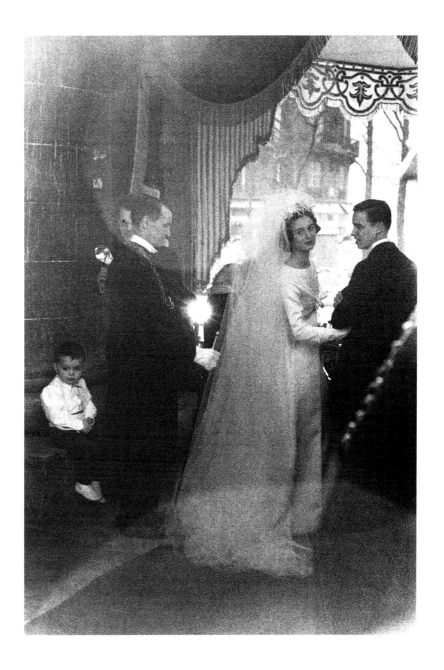

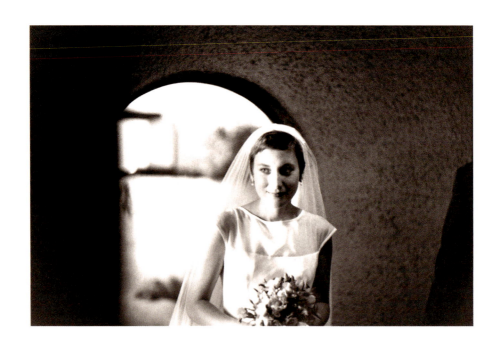

8

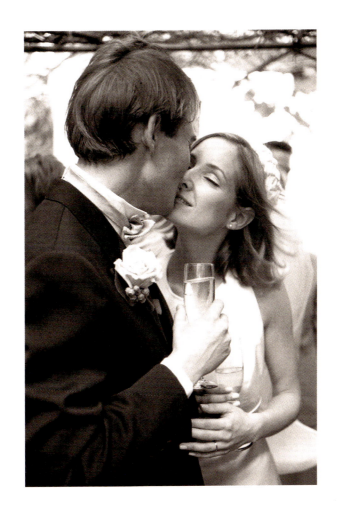

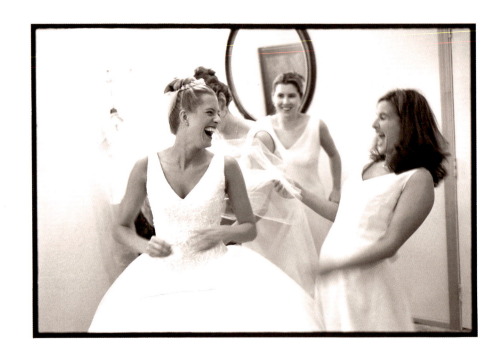

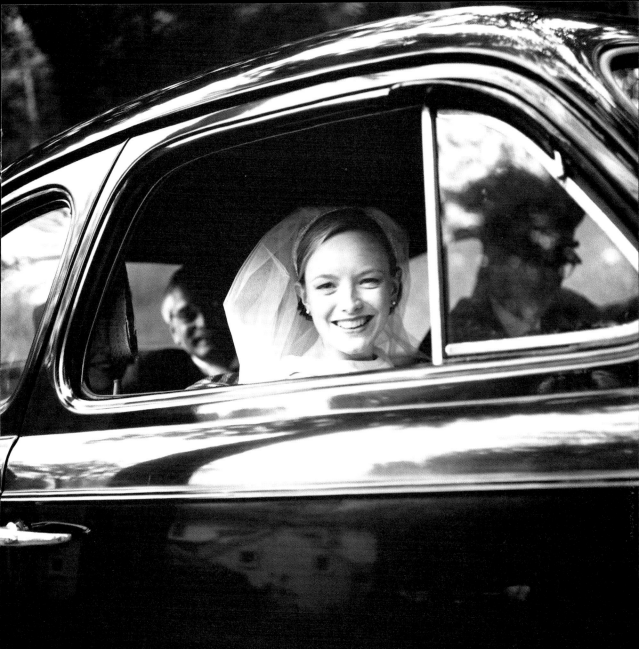

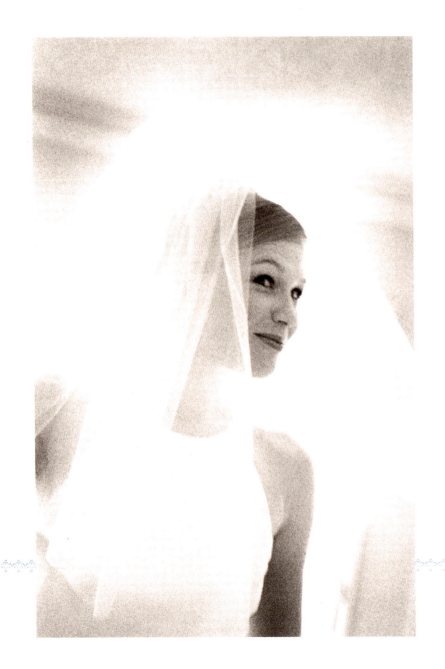

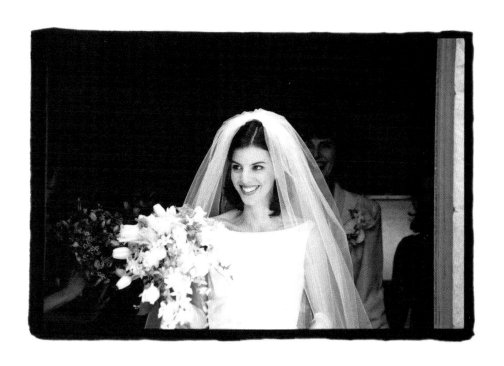

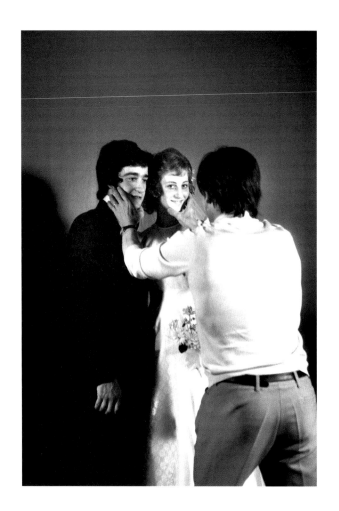

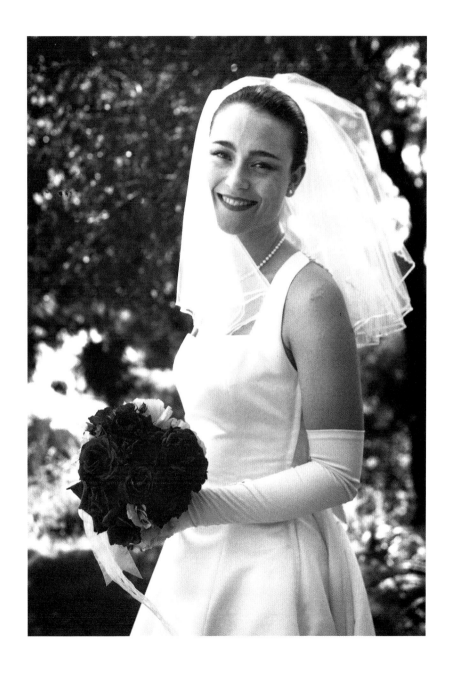

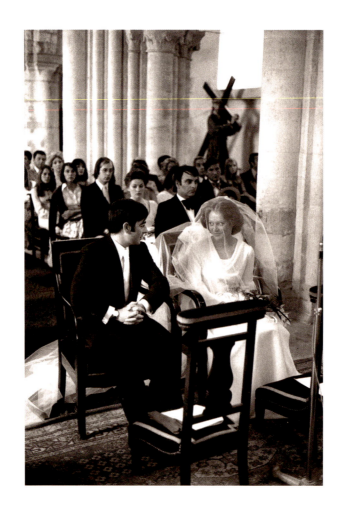

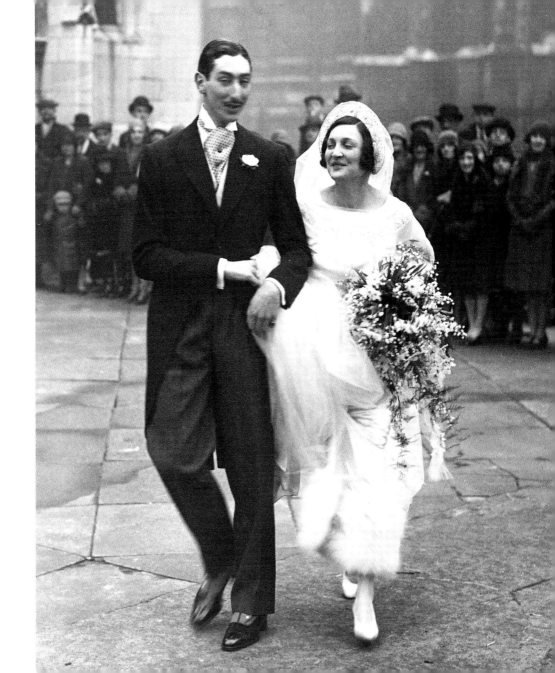

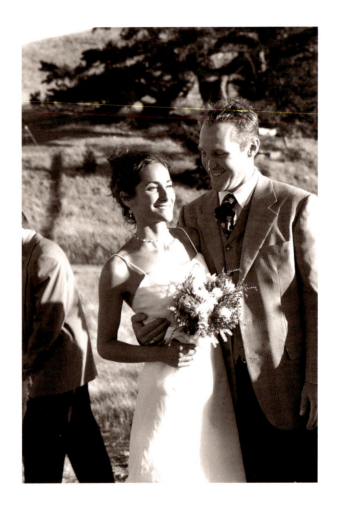

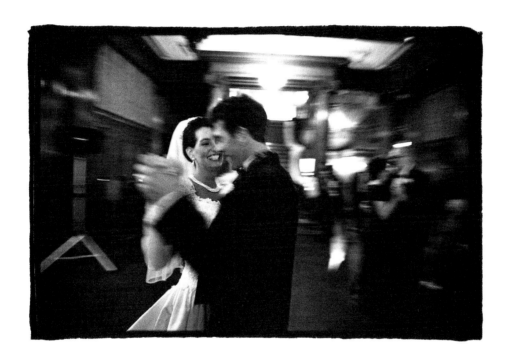

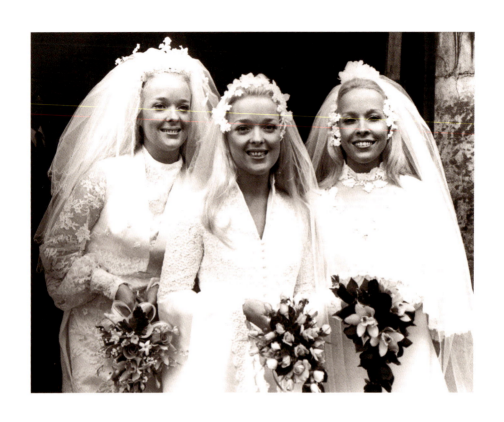

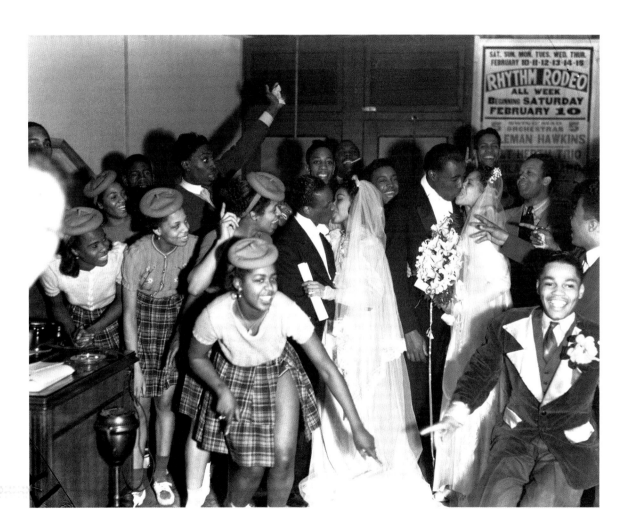

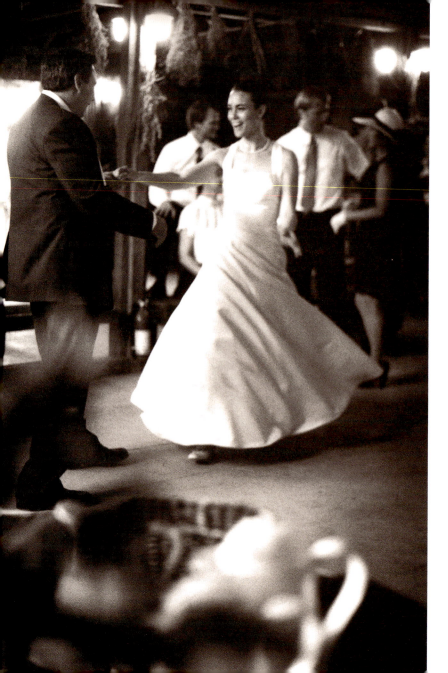

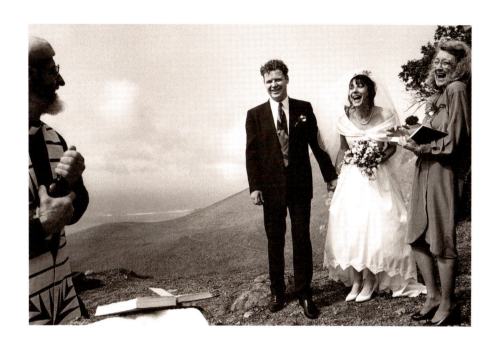

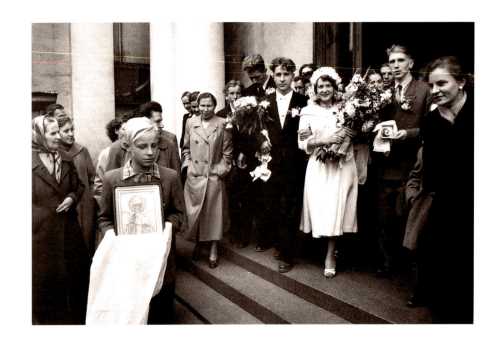

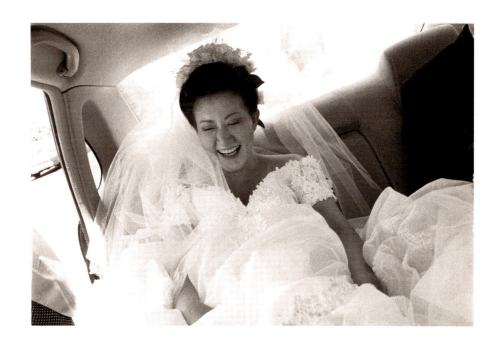

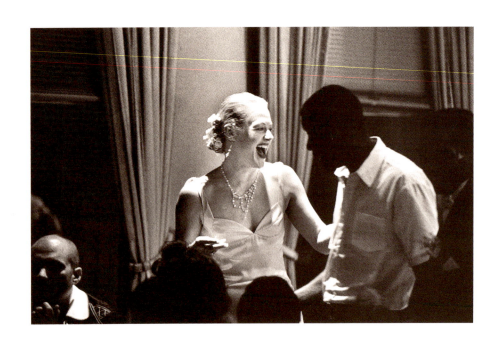

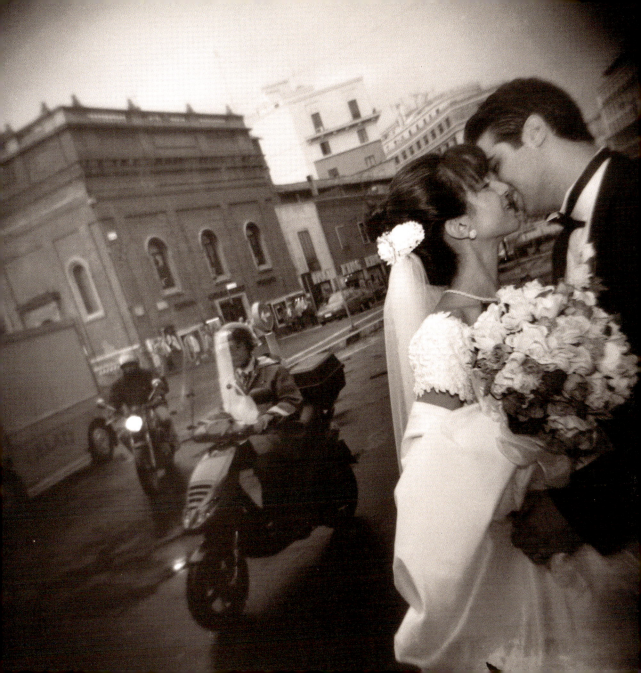

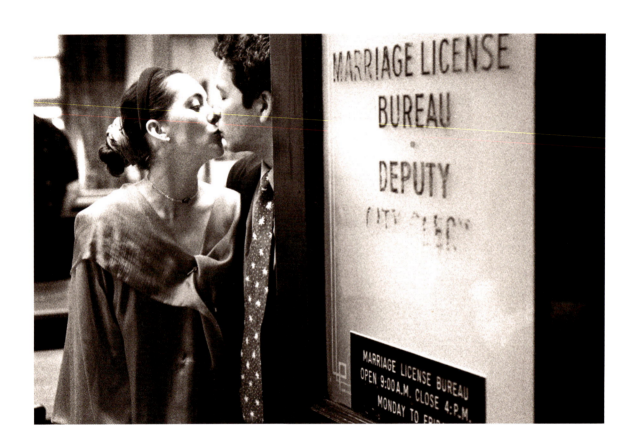

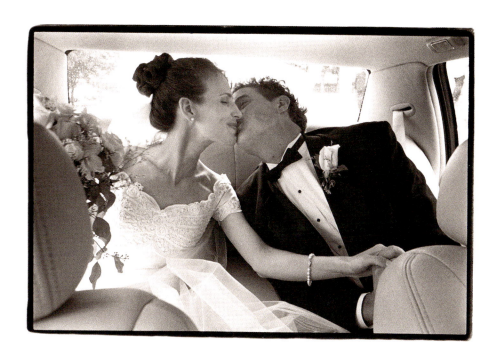

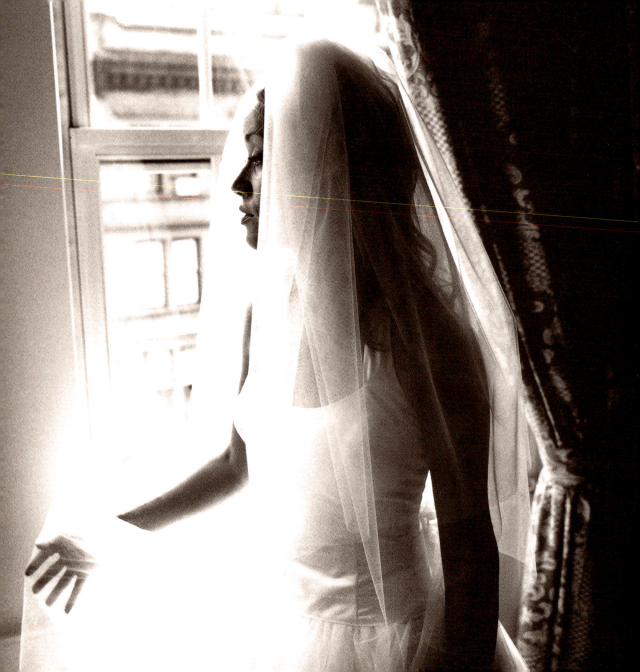

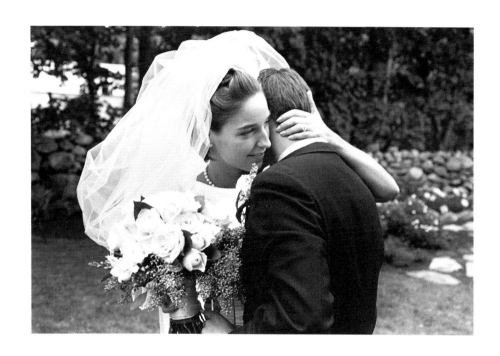

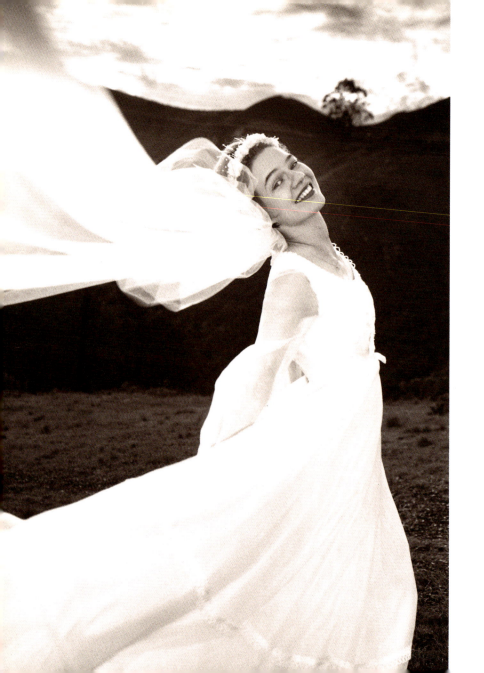

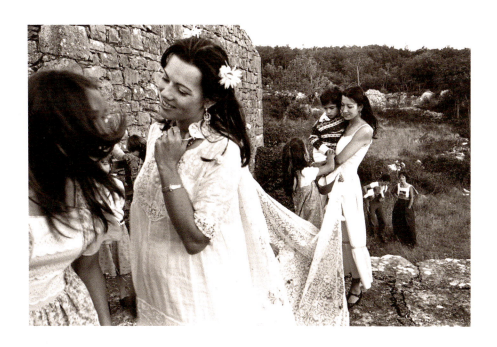

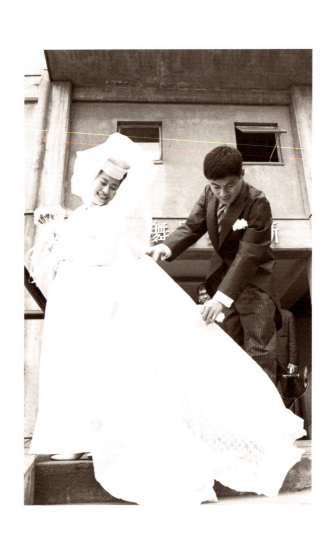

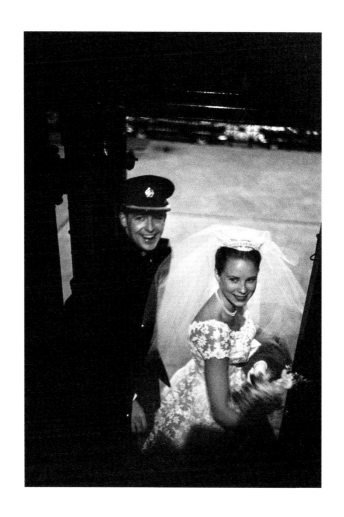

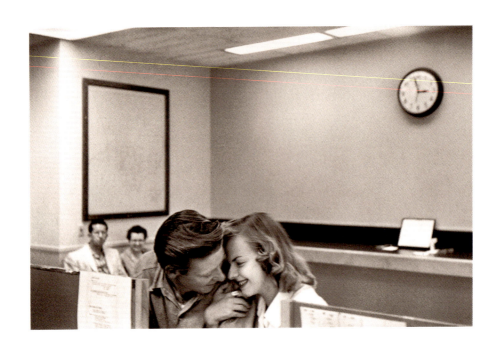

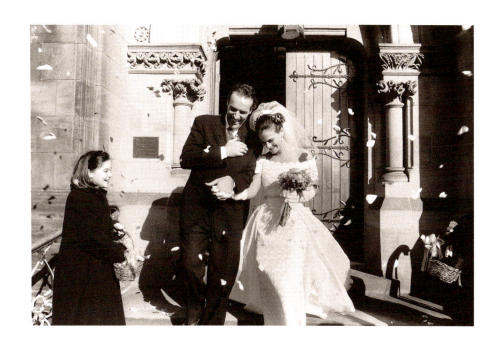

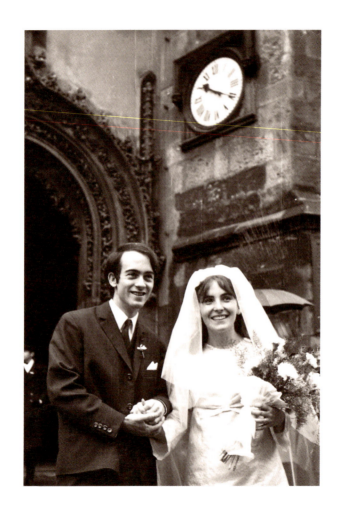

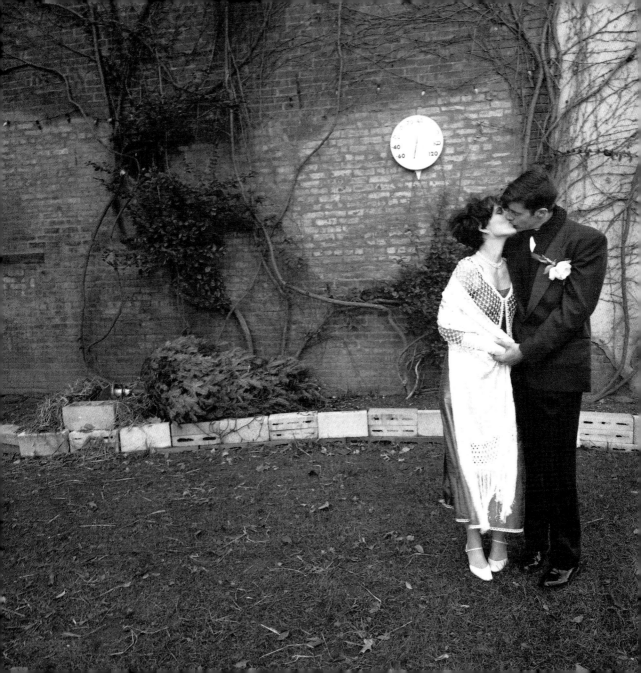

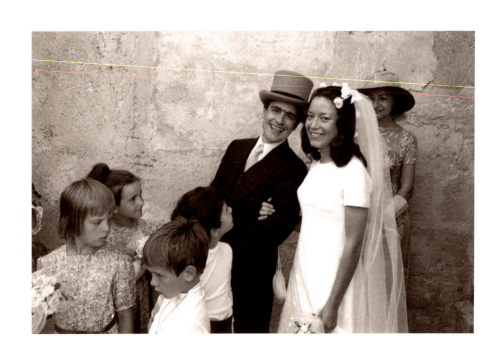

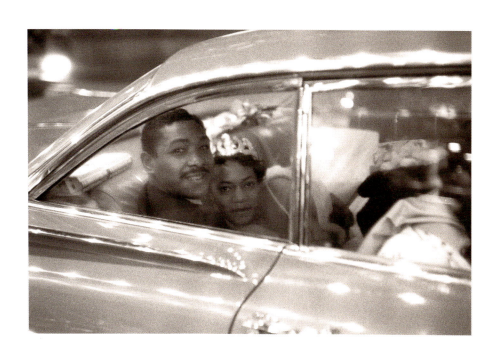

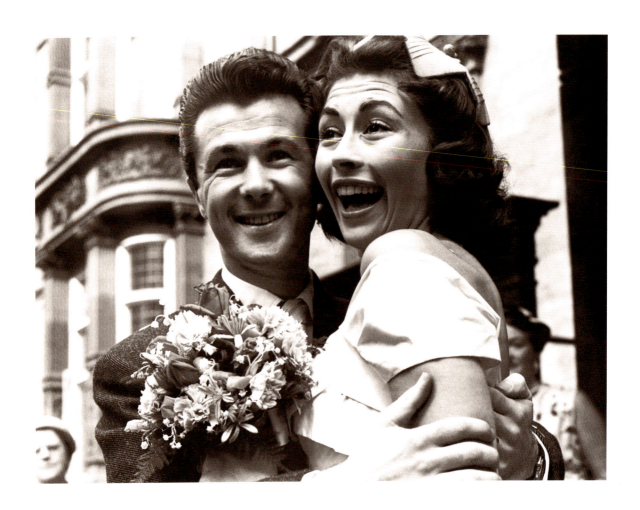

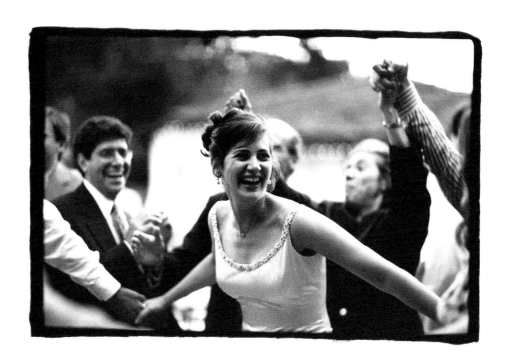

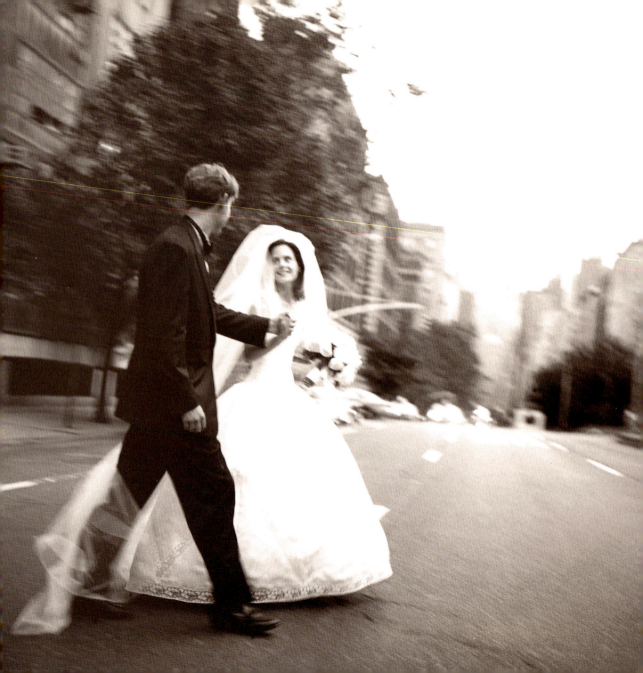

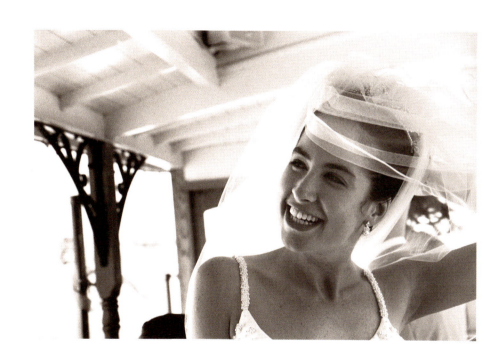

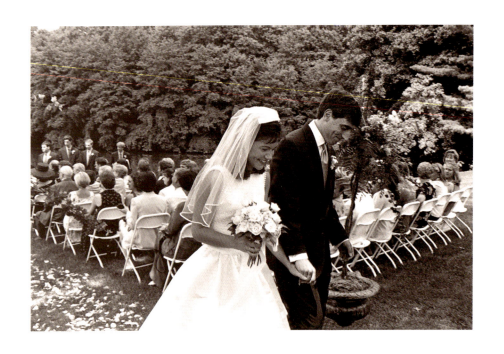

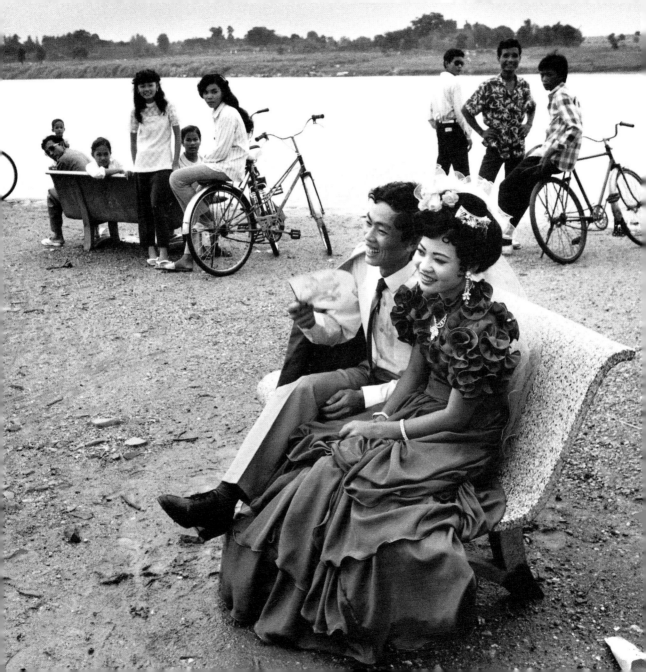

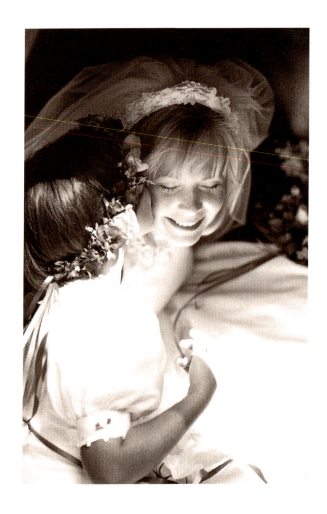

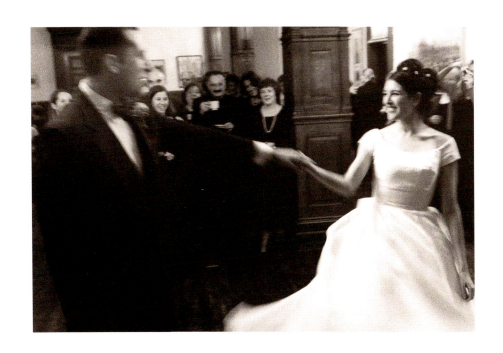

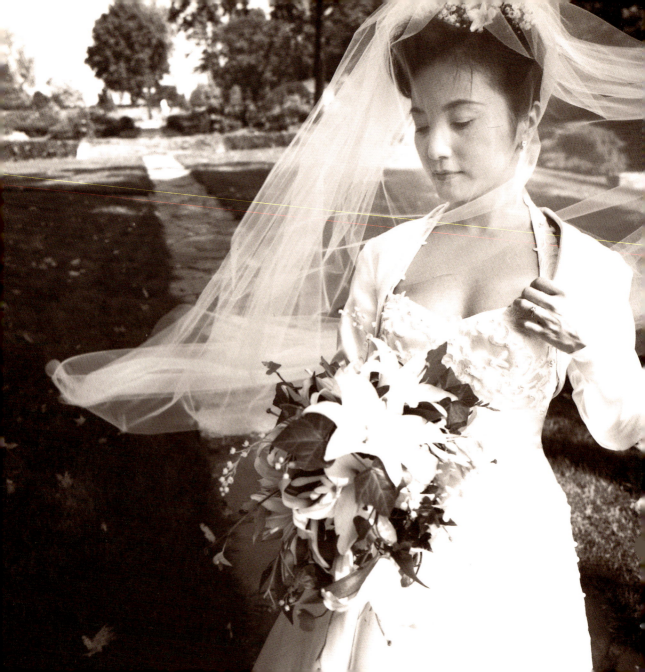

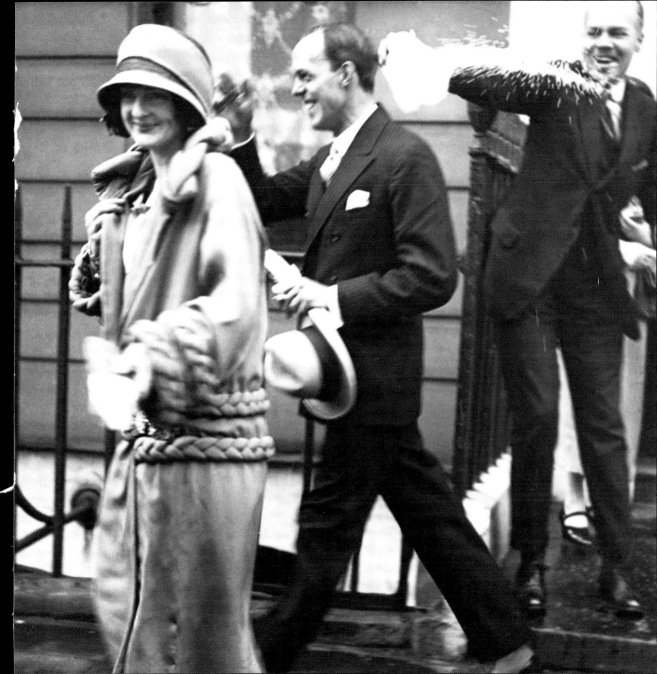

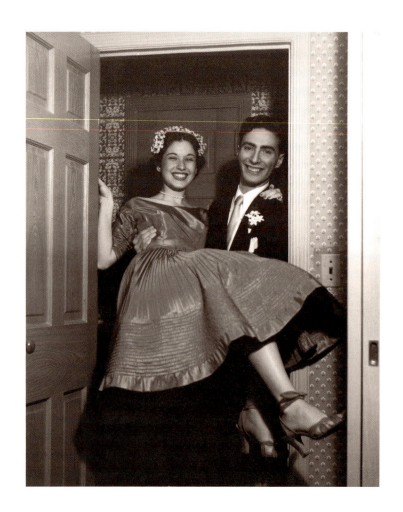

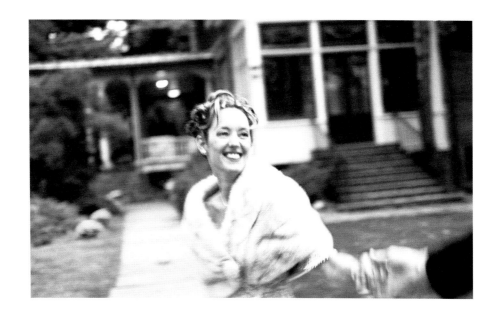

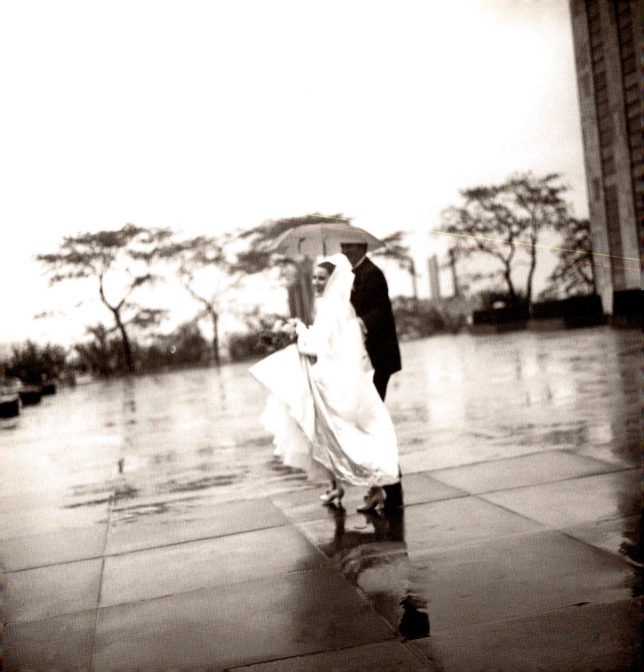

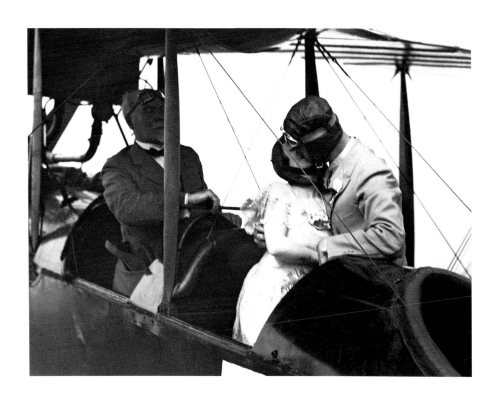

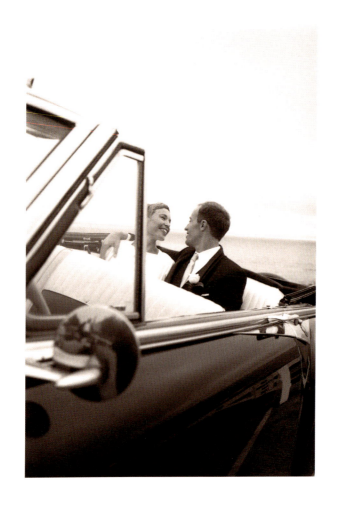

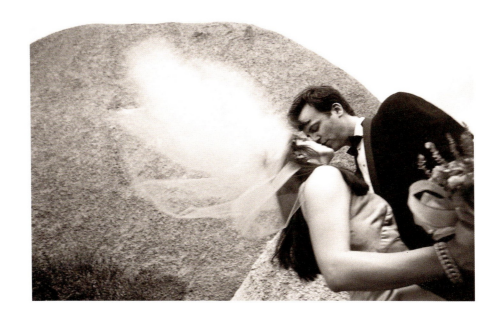

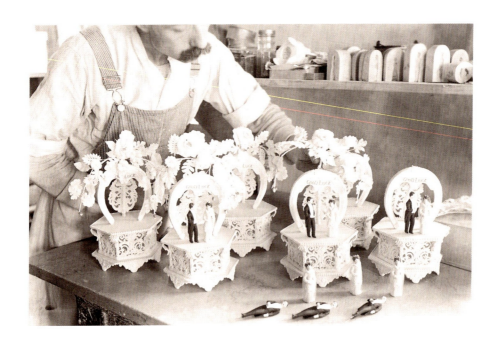

plates

1. *Marriage, NY,* 1999. © Evan Nisselson. San Francisco, CA.

2. *San Francisco,* 1965. Photographer unknown. Courtesy of Duane Archives. San Francisco, CA.

3. *Marie and Sam,* 1997. © Rick Chapman. San Francisco, CA.

4. *The Hamptons,* 1996. © Holger Thoss. New York, NY.

5. *Stanford, CA,* 1997. © Joshua Ets-Hokin. San Francisco, CA.

6. *Getting Ready,* 1998. © Thayer Allyson Gowdy. San Francisco, CA.

7. *France,* 1962. © Bruce Davidson/Magnum Photos, Inc. New York, NY.

8. *San Francisco,* 1997. © Joshua Ets-Hokin. San Francisco, CA.

9. Untitled, n.d. © Philippe Cheng. New York, NY.

10. Untitled, n.d. © Craig Strong. Portland, OR.

11. *Bucks County, PA,* 1995. © John Dolan. New York, NY.

12. *South Lake Tahoe, CA,* 1998. © Thayer Allyson Gowdy. San Francisco, CA.

13. Untitled, 1998. © Joshua Ets-Hokin. San Francisco, CA.

14. Untitled, n.d. © Guy Le Querrec/Magnum Photos, Inc. New York, NY.

15. *A Bride's Portrait,* 1998. © Thayer Allyson Gowdy. San Francisco, CA.

16. *France,* n.d. © Jean Gaumy/Magnum Photos, Inc. New York, NY.

17. *Westminster,* 1929. Photographer unknown. © Underwood Photo Archives, Inc. San Francisco, CA.

18. *Mount Tamalpais, September 20th,* 1997. © Michael Johnson. San Francisco, CA.

19. *San Francisco,* 1994. © Joshua Ets-Hokin. San Francisco, CA.

20. *Triplets Marry, Kent, England,* 1975. Photographer unknown. © CORBIS/Hulton-Deutsch Collection.

21. *Swing Dancing at Double Wedding, Harlem,* n.d. Photographer unknown. © CORBIS/Bettmann.

22. *Last Dance,* 1997. © Thayer Allyson Gowdy. San Francisco, CA.

23. *The Headlands,* 1993. © Audrey Shehyn. San Francisco, CA.

24. *Moscow, USSR,* 1958. © Marilyn Silverstone/Magnum Photos, Inc. New York, NY.

25. Untitled, n.d. © Tory Read. Denver, CO.

26. *At the Cliff House, San Francisco,* 1996. © Sandra Lee. San Francisco, CA.

27. *Rome,* n.d. © Sylvia Plachy. New York, NY.

28. *Staten Island, NY,* 1996. © Holger Thoss. New York, NY.

29. Untitled, n.d. © Tory Read. Denver, CO.

30. Untitled, n.d. © Philippe Cheng. New York, NY.

31. *Madison, CT,* 1995. © Jason Walz. New York, NY.

32. *San Francisco, CA,* 1997. © Daniel Gohstand. San Francisco, CA.

33. *France,* 1979. © Guy Le Querrec/Magnum Photos, Inc. New York, NY.

34. *Bride in Paper Dress, Tokyo, Japan,* 1964. Photographer unknown. © CORBIS/Bettmann.

35. *St. Patrick's Cathedral, NY,* 1958. © Burt Glinn/Magnum Photos, Inc. New York, NY.

36. *Young Couple,* n.d. © Elliott Erwitt/Magnum Photos, Inc. New York, NY.

37. Untitled, n.d. © Melchior Digiacomo. Harrington Park, NJ.

38. *Prague, Old Town Square,* 1967. Pavel Macek. Courtesy of Duane Archives.

39. Untitled, n.d. © Philippe Cheng. New York, NY.

40. *Montpellier, France,* 1975. © Martine Franck/Magnum Photos, Inc. New York, NY.

41. *Newlyweds, NYC,* 1959. © Rene Burri/Magnum Photos, Inc. New York, NY.

42. *Wedding of Nanette Newman,* 1955. Photographer unknown. © CORBIS/Hulton-Deutsch Collection.

43. *Palo Alto,* 1997. © Joshua Ets-Hokin. San Francisco, CA.

44. *Park Ave, NYC,* 1997. © John Dolan. New York, NY.

45. *Lord Inverclyde's Wedding, Westminster,* n.d. Photographer unknown. © Underwood Photo Archives, Inc. San Francisco, CA.

46. Untitled, n.d. © Philippe Cheng. New York, NY.

47. *Cable Car Ride, San Francisco,* 1998. © Daniel Gohstand. San Francisco, CA.

48. *Fort Wayne, IN,* 1998. © Jason Walz. New York, NY.

49. *Cambodia,* 1989. © John Vink/Magnum Photos, Inc. New York, NY.

50. *A Flower Girl's Kiss,* 1997. © Thayer Allyson Gowdy. San Francisco, CA.

51. *First Dance, Brooklyn,* 1999. © Evan Nisselson. San Francisco, CA.

52. Untitled, n.d. © Philippe Cheng. New York, NY.

53. *Olema,* 1996. © Audrey Shehyn. San Francisco, CA.

54. *New York City,* 1996. © Holger Thoss. New York, NY.

55. *Newlyweds, Abbeville, LA,* 1976. © CORBIS/Philip Gould.

56. *New Hampshire, USA,* 1958. © Elliott Erwitt/Magnum. Photos, Inc. New York, NY.

57. *Actress Weds Barrister,* n.d. Photographer unknown. © Underwood Photo Archives, Inc. San Francisco, CA.

58. Untitled, n.d. Photographer unknown. Courtesy of the Duane Archives. San Francisco, CA.

59. Untitled, n.d. © Philippe Cheng. New York, NY.

60. *U.N. Plaza, NYC,* 1998. © John Dolan. New York, NY.

61. *After the Ceremony a Thousand Feet in the Air, NJ,* n.d. Photographer unknown. © Underwood Photo Archives, Inc. San Francisco, CA.

62. *Just Married,* 1998. © Thayer Allyson Gowdy. San Francisco, CA.

63. Untitled, n.d. © Philippe Cheng. New York, NY.

64. Untitled, n.d. Photographer unknown. © Underwood Photo Archives, Inc. San Francisco, CA.